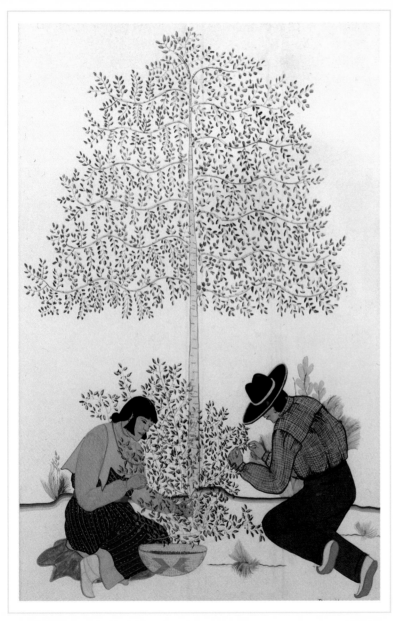

*Picking Berries*

1936

Casein

Courtesy of Bandelier National Monument,

National Park Service

# PABLITA VELARDE
## Painting Her People

by Marcella J. Ruch

**NEW MEXICO**
M A G A Z I N E

1

Pablita Velarde

1992

Photo by Herb Lotz

Courtesy of Pablita Velarde

W orking with Marcella Ruch was a very
pleasant experience for me. She is a
very nice lady. She was patient with me when I
had memory lapses, as it happened many times.
I am very happy that she wanted to do this book
on me – I think the book is beautifully done.

*Pablita Velarde*

*11 - 18 - 2000*

# PABLITA VELARDE
## Painting Her People

by Marcella J. Ruch

**NEW MEXICO**
M A G A Z I N E

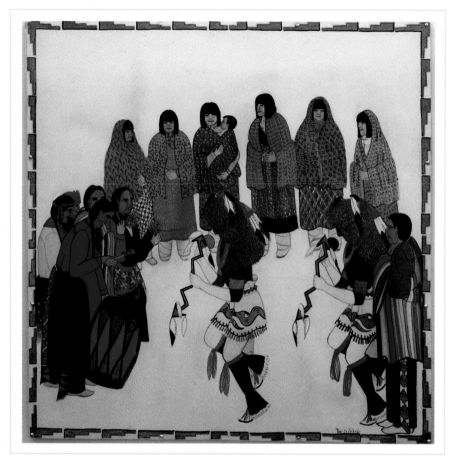

*Buffalo Dance*

1937

Casein

Permanent collection of Bandelier National Monument,

National Park Service

Author:  Marcella J. Ruch

Executive Editor:  Bette Brodsky

Editor:  Arnold Vigil

Photographs: Mittler Photography Studio

Book Design and Production:  Bette Brodsky

Publisher:  Ethel Hess

Library of Congress Control Number:  00-093513

ISBN: 0-937206-65-2 (soft)

0-937206-67-9 (hard)

Printed in Korea

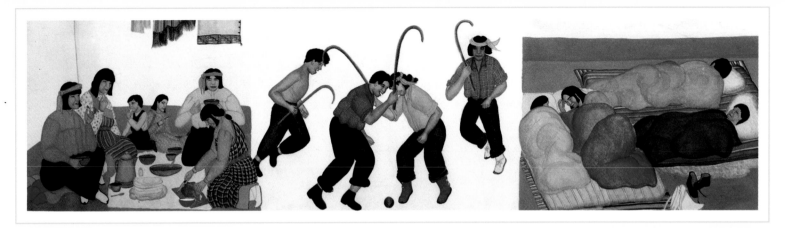

*Three Family Scenes*

1933

Casein

Permanent collection of Bandelier National Monument,

National Park Service

# TABLE
# *of*
# CONTENTS

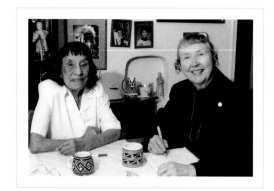

Pablita Velarde and Marcella Ruch

November 2000

Photo by Steve Larese

# Author's Notes

by Marcella J. Ruch

Pablita Velarde first came into my life in the summer of 1982. I spent a week camping at Bandelier National Monument, northwest of Santa Fe, with my husband Peter. There I became fascinated with Pablita's life and art. I bought my first Pablita print, *The Basket Dance*, in the gift shop at Bandelier. I tried to buy a book about her, but none was available. The day we ended our vacation, I called Pablita and explained to her that I would like to write a children's picture book about her life. I told her I was a teacher and had tried to buy a book about her to share with my students.

Pablita invited me to her home to talk about my idea, and after she met me and thought about it a while, she gave me written permission to write her story. During the course of eight years of interviews, I began writing a children's book and to my delight it has grown into a coffeetable/picture book with her art.

The first few years that I interviewed Pablita in her Albuquerque home we focused on the facts of her life. I travelled from my home in Colorado Springs and showed her every few pages as I finished them. I promised her that she had veto power over my manuscript. I wanted her to like what I wrote. She was decisive and would quickly say, "That's all right," or, "I don't want you to say anything negative about any person in my life."

Eventually Pablita began to trust me. She essentially is a very private person and it was easier to talk about the facts. In the last three years the book began to really take shape as she shared her fears, her hopes, her joys and her sor-

rows. It became the tale of her struggle to grow as a woman artist, at first within the Santa Clara community and, later, in the world. This struggle was only made more difficult by her divorce, her single-parent status and the initial low market value of Indian art.

The more I learned about Pablita's life, the more I knew that this was a story that had to be told. I followed Pablita to the Eight Northern Indian Pueblos Art Show and Sale. I met her family, and watched her autograph and sell her work. I even bought a small watercolor that I treasure. Twice I was privileged to sit by her to watch the dances on Santa Clara Feast Day. I experienced how her people love her and feasted twice with her sister Jane, or Lucaria, as the story tells.

Since I began the story of her life, she has earned many additional awards and honors. My admiration for her has turned to

*Santa Clara Basket Dance* (#0237.405)

Ca. 1936

Tempera

From the Collection of Gilcrease Museum, Tulsa, OK

amazement. I am humbly grateful that she allowed me into her life.

The story that I have created is not verbatim, but it is the story she wants to tell. She is happy with my work. Pablita herself has written a book, *Old Father Storyteller*. She found writing extremely difficult. This perspective made her respectful of my work, and she often encouraged me.

As I worked, she brewed tea for me, made me welcome, and occasionally provided sleeping quarters for me. Often we sat at her kitchen table while I interviewed her. When I brought her text to approve, we shared her couch so we could review the writing together.

Over the years this book evolved out of persistence and goodwill. I have come to love Pablita, and I hope all who read her story will feel the admiration, respect and love from me to her that made this book a reality.

# Introduction

By Joyce M. Szabo
Associate Professor of Art History
University of New Mexico

Pablita Velarde's art is richly layered in imagery, technique and the very way in which it has grown. Velarde was the first woman to attend the Studio at the Santa Fe Indian School, being among the earliest students to enroll when it opened its doors in 1932. She continues to work in the strongly outlined, flatly painted style she developed there but also explores new compositions and media. Always, however, her work is closely tied to her background as a woman from Santa Clara Pueblo and the life she lives both at the village and outside it.

The Studio developed in the early 1930s with Dorothy Dunn as its guiding force. Dunn and her students drew upon earlier 20th-century works by Pueblo artists who, encouraged by teachers at day schools in the villages, rendered views of their lives, especially the dances held in the pueblos. Both the earlier Pueblo paintings and those of the Studio became strongly narrative in the hands of many Native American artists. Among the most closely connected to that narrative aspect is Pablita Velarde who, for nearly seven decades, uses her art to tell vivid stories about Pueblo life and her place within it. She employs the tenets of the Studio style to its best advantage, layering multiple patterns of textiles and figures in motion within villages filled with daily activities.

Velarde holds a singular position in the history of Native American painting, especially because of her early, pivotal role as a woman artist in a field dominated by men. Despite the fact that many discouraged her from painting because it was not something women did, she persevered. Her guiding force in this was Tonita

Peña from San Ildefonso, one of the earlier artists encouraged by Esther Hoyt, a teacher at the pueblo. Velarde met the San Ildefonso woman when Peña was painting murals at the Santa Fe Indian School; Peña was the sole woman among several men working on the mural project. Peña was Velarde's role model in her early days; Pablita respected her work and knew that if Peña had stayed the course, so could she.

Throughout her long career, Velarde broke many additional barriers. In doing so, she became to others what Tonita Peña was to her. It was not an easy road. While her national and international exhibition record is now impressive, Velarde was passed over for various commissions in the past, including those for a new U.S. Department of the Interior building in Washington, D.C., in 1939; Native American men completed the murals instead. When she was in her 20s, however, she received an important commission to paint 84 images of Pueblo life at Bandelier National Monument. Almost four decades later, she painted a mural at the new Indian Pueblo Cultural Center in Albuquerque, and broke a commonly perceived rule about Pueblo painting – she included a self-portrait in the composition.

Velarde has attained a well-respected position as an artist evident by many first place and grand prize awards in juried competitions, including the Philbrook Annual in Tulsa, OK.

Not content to rest on her laurels, Velarde continues to experiment. While maintaining ties to the Studio style, she began to use earth pigments ground from various rocks. Her works from the 1950s reflect her knowledge of experiments other artists were making, including those of Joe Herrera of Cochití. Herrera is Tonita Peña's son, and the continuing circle of influence underscores the close connection between many artists in the Southwest. Velarde's own daughter, the late Helen Hardin, became a well-recognized artist. Various innovations that Hardin made also influenced her mother. Hardin's daughter, Margarete Bagshaw-Tindel, continues the family tradition of painting.

While Velarde draws upon rock art, pottery designs, Cubism and many other sources to make her work visually intriguing, her greatest contributions are the views of Pueblo life that she portrays in her paintings. Velarde says that she wants to be remembered by her work as an artist; this is assured, for her paintings, layered with meanings, will always tell her stories.

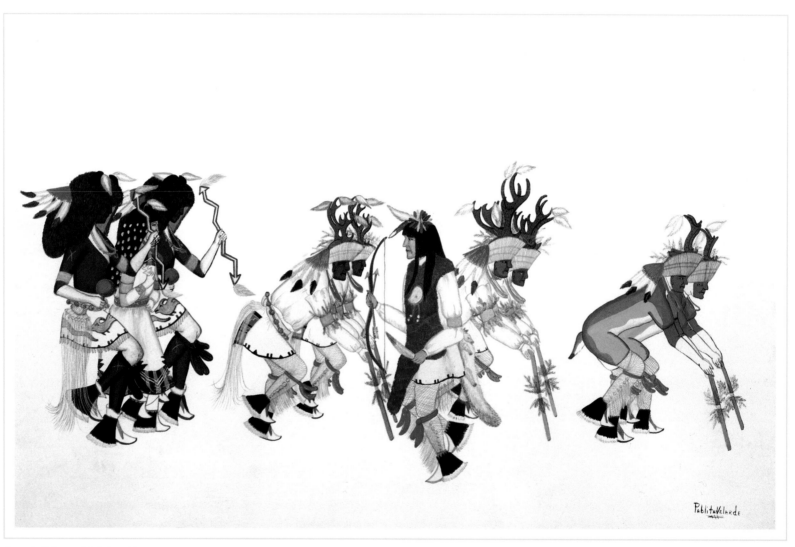

*Deer, Buffalo, and Antelope Dance*

1940

Casein

Permanent collection of Bandelier National Monument,

National Park Service

# PABLITA VELARDE
## *Painting Her People*

by Marcella J. Ruch

My father, Herman, took three of his four daughers from Santa Clara Pueblo to St. Catherine's School two years after my mother died from the coughing sickness. My three brothers had died, too, from a fever. It was just the girls who were left. Lucaria, my little sister, stayed with my stepmother, Clara. My father drove the old wooden wagon pulled by two work horses. My sisters Legoria and Rosita bounced with me in the back of the wagon over the rocky road. When the horses became tired, we made camp beside the road and spent the night. The next day we jiggled on towards Santa Fe. It was 40 miles and it took us two days. When my father left us at St. Catherine's School it was 1920 and I was 5 years old.

At the school I knew fear for the first time. I was afraid at first of these tall, strange women in black dresses. They wouldn't let me talk because I spoke only Tewa, the Santa Clara Pueblo language. I was so homesick at St. Catherine's that I cried every day for weeks. I missed my little sister, Lucaria; my bed; my father; my grandmother, Qualupita; and the Santa Clara Pueblo.

Opposite: St. Catherine Indian School

Santa Fe, NM 1912

Photo by Jesse L. Nusbaum

Courtesy of Museum of New Mexico, Neg. No. 61553

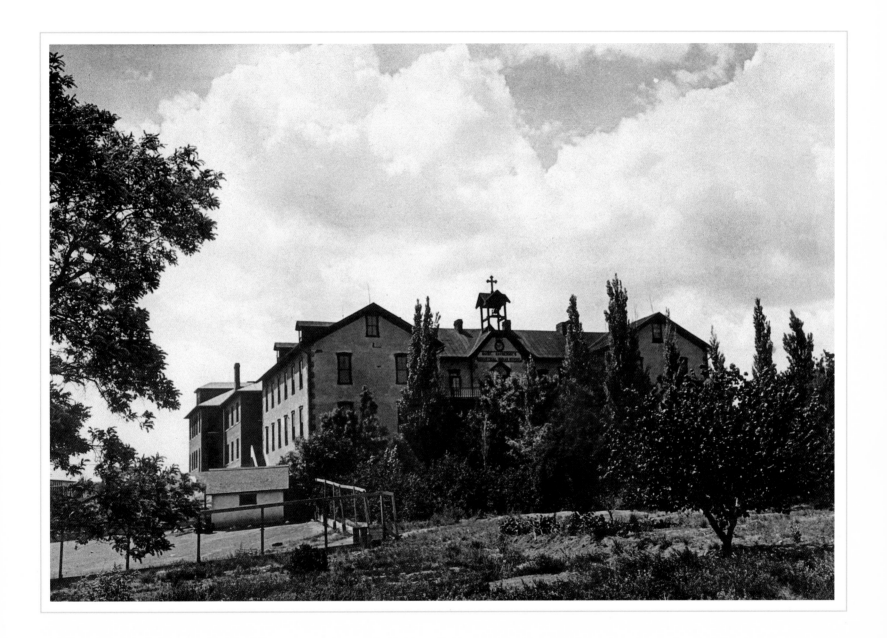

13

The only time that I stopped crying was when someone brushed my hair. While my hair was being brushed, it felt like my own grandmother was caring for me. The nuns were skinny, strong women with kind and loving eyes. They never seemed to tire of brushing my hair. Their long black dresses matched my hair. They soothed my sadness as they held me on their laps and hugged me and in time made me feel loved. The rule at St. Catherine's was that only English could be spoken. That is why I cried in silence until I learned to speak English. I prayed in Tewa, though, because God did not care what language I spoke. Praying in Tewa is a habit I have kept. The nuns taught me to pray in English. I still pray every day in both languages.

After a while when I stopped crying so much, the nuns taught me to read, write and speak English all at the same time. I had to make hundreds of rows of Os, Is and Ls. As I learned to say words in English, I was allowed to speak. Soon I could talk in sentences in English to my sisters. They each knew some English when we came to school, but I knew none. However, I learned fast and became an excellent student.

Opposite: Classroom, St. Catherine Indian School
Santa Fe, NM Ca. 1950
Photo by Tyler Dingee
Courtesy of Museum of New Mexico, Neg. No. 120238

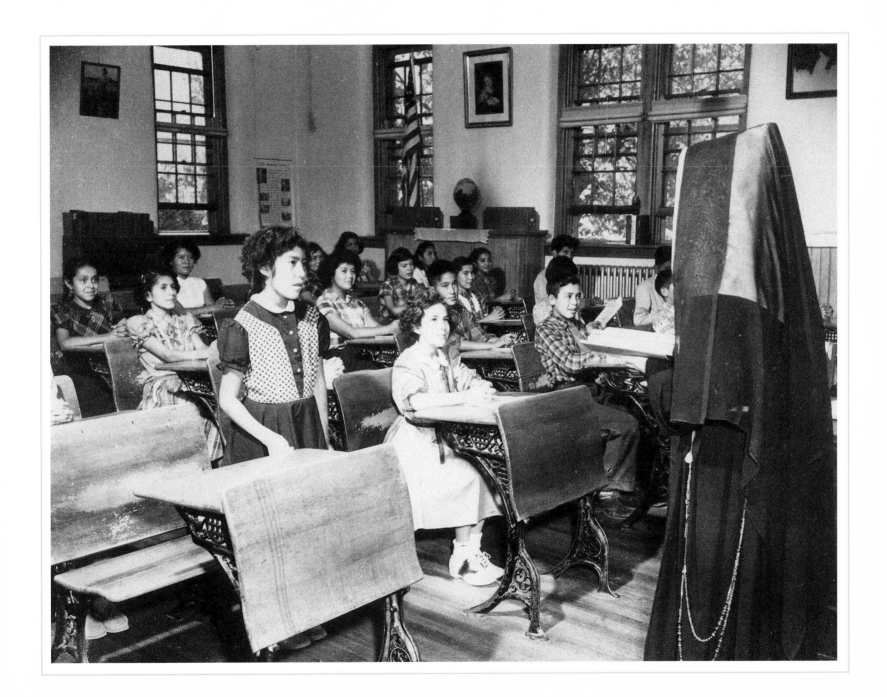

I was always hungry at St. Catherine's School. So were the nuns, our teachers, as well as the other Indian children. The nuns shared every bit of food they had, but it was never enough. We were usually still hungry after each meal. The baker, who made and sliced the bread every day for each meal, cut the slices on a wooden cutting block that had four legs. Each time he sliced bread, he carefully scraped the crumbs from the top into a small pail, saving every crumb. Every afternoon the bread crumbs would almost fill his small pail. The baker would bring the pail to us while we played at recess. We ran to him. He let us grab fists full of crumbs. We stuffed them in our mouths like little pigs. We drank some water and ate some more crumbs until the pail was empty. Then we drank some more water, and for a little while, we were not hungry.

Opposite: Baking bread, St. Catherine Indian School
Santa Fe, NM Ca. 1950
Photo by Tyler Dingee
Courtesy of Museum of New Mexico, Neg. No. 120236

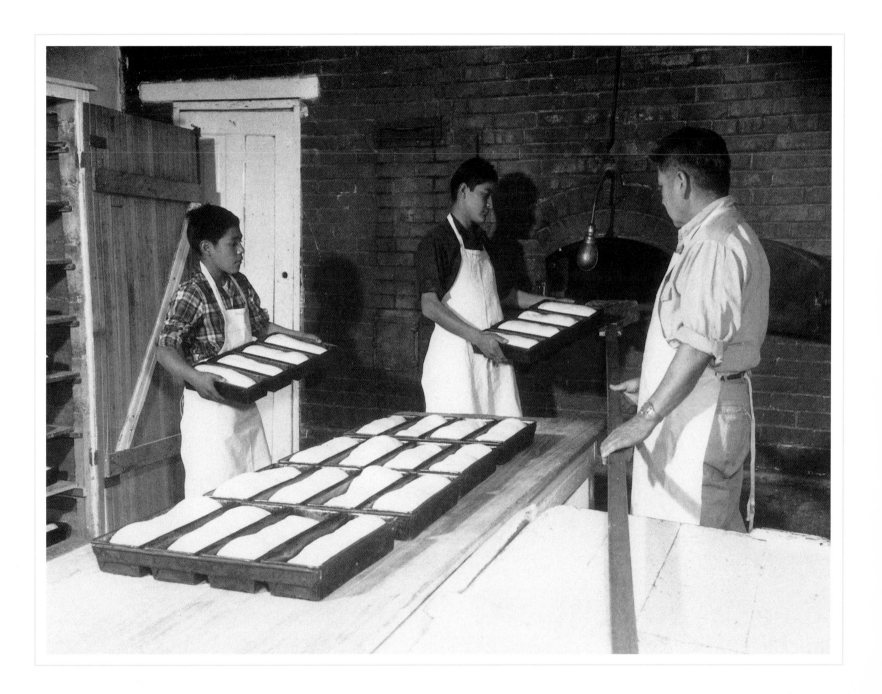

One day during the summer while we were home from school, my father found a tired one-eyed brown teddy bear when he hauled trash to the dump. He proudly brought it home to us and instantly that bear had four mommas. We named it Teddy and we all loved him fiercely. There were four of us and only one Teddy so we each used to hide him so our sisters could not find him. Then at bedtime we snuck Teddy from his hiding place to hug him as we fell asleep. Sometimes I was lucky and went to sleep holding Teddy. He was always gone from my arms when I woke up. When my eyes were fully open, I found Teddy getting a hug from one of my sleeping sisters. We slept on the floor on mats. Each morning we rolled the mats, tied them and used them for sitting.

We slept outdoors after my mother died, except in winter. A doctor had told my dad that we could catch TB sleeping where my mother had died. He threw tarps over us if it rained. He wanted us to live.

Opposite: Detail, *Three Family Scenes*

1933

Casein

Permanent collection of Bandelier National Monument,

National Park Service

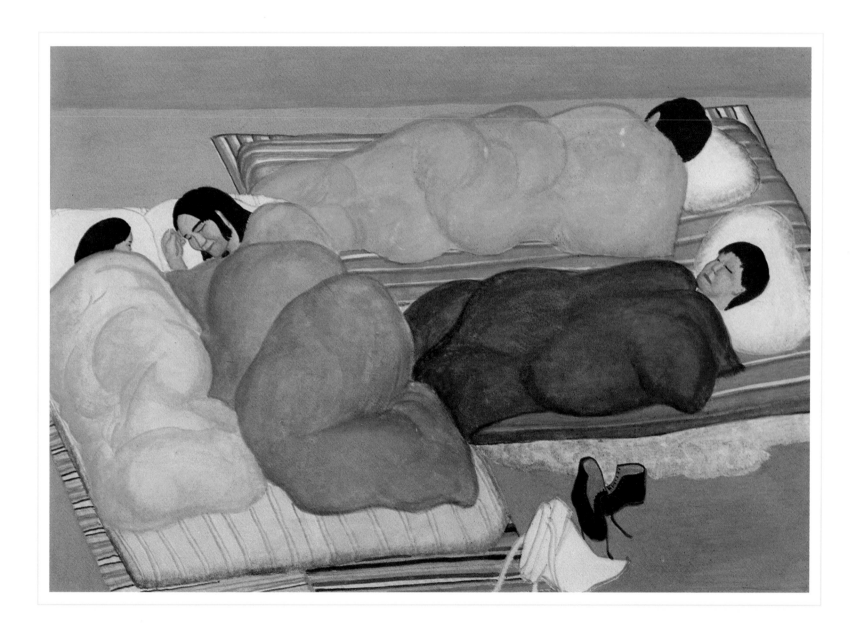

19

When I was 8 years old, my best friend, Flora, was so home-sick that I decided to leave school and walk home with her. We started walking north toward the Santa Clara Pueblo. A kindly neighbor gave us a ride in his old pickup truck and drove us to my father's part of the pueblo. My father was furious with me. He told me, "Your job is to study hard and learn all you can. Your name is Pablita. Your Indian name is Golden Dawn. Never again can you bring sadness to my heart." From that day on I tried hard to live up to my name and to pay attention to my lessons. However, my friend Flora never went back to school, not even for one day.

ARM
*Strength, courage and character to raise above oneself*

WRIST
*To bend, tolerance towards others*

HAND
*Charity and love, extend to others help and kindness*

SPLIT LEAF
*Sharing knowledge with others*

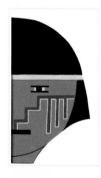

EYES
*To see more clearly*

MOUTH
*To speak truthfully*

COURSE
*Four directions – paths of the Earth to reach every trail*

SEEDS
*For wisdom and new thoughts*

Opposite: *The Seed Bearer*, from *Old Father Storyteller*

1970

Earth pigment, 14" x 13"

Courtesy of Mr. and Mrs. B.W. Miller

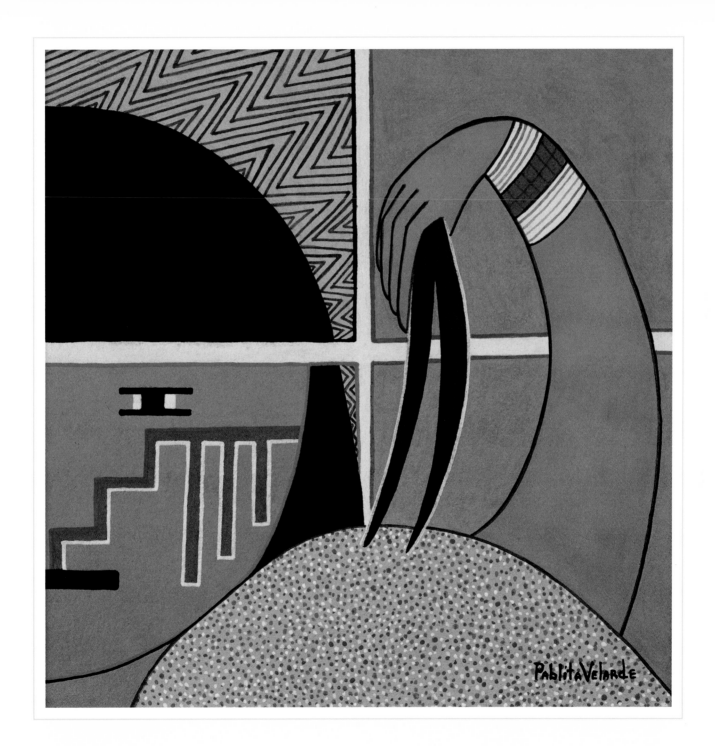

21

My father put me on the train the next morning. I said good-bye to Teddy, to my grandmother and to my father. That had been the only night of my life that I was able to hug Teddy all night long. I never had Teddy all to myself again, but I never ran away from school again, either.

The black smoke billowed out around the train as we chugged back to Santa Fe. The horsehair benches scratched my legs. I sat straight up, vowing to be a good girl in the future. My sisters, Legoria and Rosita, were glad to see me safely back at school, and so were the nuns who received a telegram from my father and came for me at the train station.

My little sister Lucaria started school about that time. The teacher couldn't pronounce or remember her name. She was teaching the children to read from a book about Dick and Jane. She finally said in exasperation, "I'll just call you Jane!" From that day to this my sister has used the name of Jane. She even signs her pottery with Jane.

Opposite: *Rainbow Dancer*

1960

Earth pigment

Courtesy of Mr. and Mrs. B.W. Miller

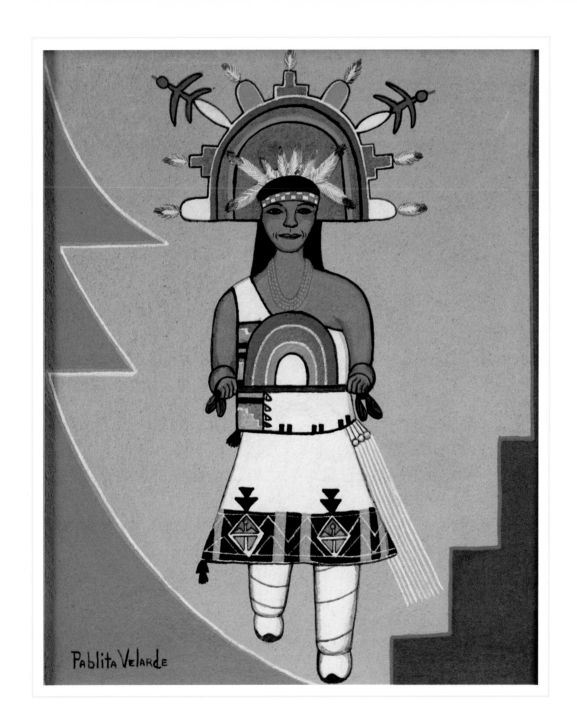

*E*very summer we went home and helped my father grow food on the mesa. My father built a small cabin there and we cooked outdoors. When my father came home with groceries in a paper sack or cardboard box, I would take charcoal from the dead fire and draw. My pictures were always burned to start the next fire. No one knew I had artistic talent, not even me. My father did not encourage me to draw, because only men were artists in our pueblo. Women had jobs that they had been doing for hundreds of years: making pottery, cooking, cleaning and taking care of the children. When I was young I also learned how to make pottery and decorate it. But I wanted to be a painter. Only one Pueblo woman ever drew pictures before I was born. Her name was Tonita Peña from the San Ildefonso Pueblo and my dream was to be just like her.

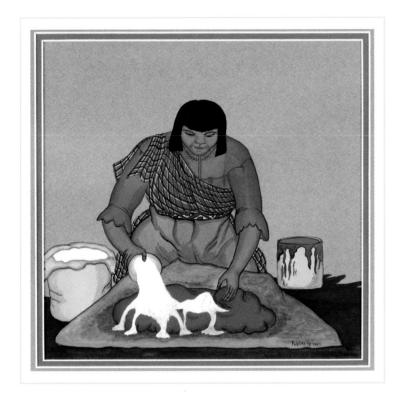

*Making Pottery at Santa Clara*

1952

Casein

Courtesy of Mr. and Mrs. B.W. Miller

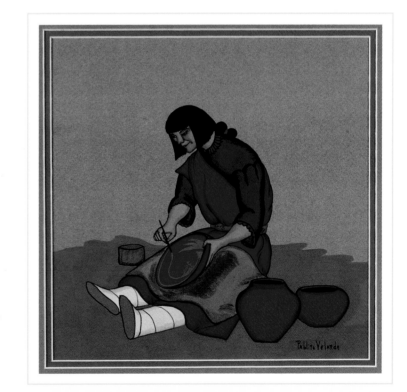

*Decorating Pottery at Santa Clara*

1953

Earth pigment, 14" x 13"

Courtesy of Mr. and Mrs. B.W. Miller

One summer while we were home from school we loved our Teddy so much he just fell to pieces. We were all heartbroken. My father had to take all of his pieces away. Not long after that, a baby horse came to live at our house and, of course, we named him Teddy. That colt was the joy of our childhood. We brushed Teddy's coat by the hour, we watered him, we fed him, we lay blankets across his back and walked him. We had to keep Teddy out of the gardens. After he was big enough we all learned to ride him. I was lucky because my father let me ride Teddy every day all summer from then until I grew up. I was the one who brought the cows home at night and locked them safely away. I could ride a horse better than the boys or my sisters.

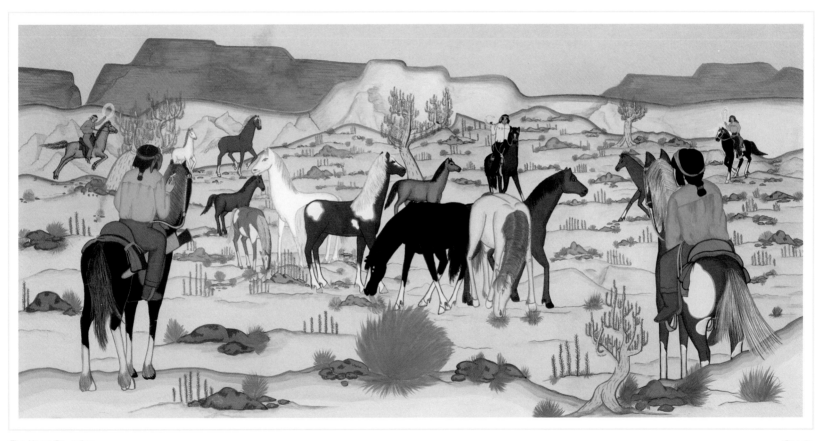

*The Horse Roundup*

1938

Casein

Permanent collection of Bandelier National Monument,

National Park Service

*E*very night on the mesa, my father gathered us around a fire and told us stories under the stars. He told us stories that his father had told him.

His father had learned them from his father and so on down through the generations. The stories were kept alive by telling them to the children. When he tired of telling a story, he would blow smoke from his pipe on another man and that man would become the storyteller. I loved to listen to the stories about the old ones who lived in the Puyé caves nearby. Our ancestors, the Anasazi, lived on that mesa for over 400 years from the late 1100s to around 1580. The first art I ever saw was in the Puyé Cliff Dwellings where the old ones drew on the walls.

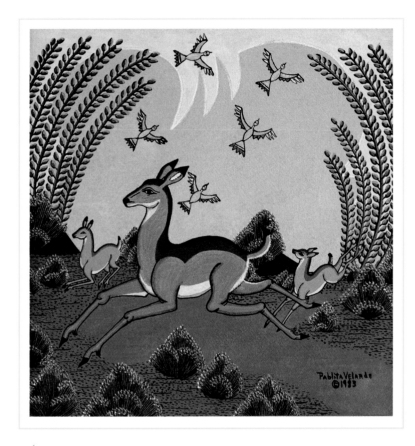

*Doe with Twins*

1983

Earth pigment

Courtesy of Mr. and Mrs. B.W. Miller

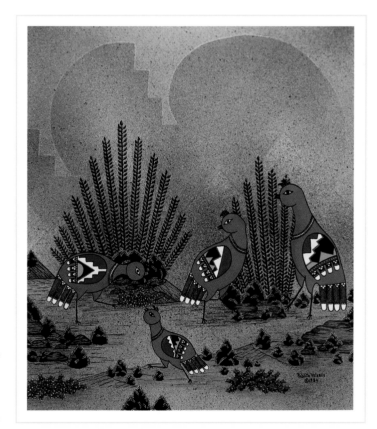

*Mimbres Quail*

1984

Earth pigment

Courtesy of Mr. and Mrs. B.W. Miller

From the mesa we could see the Río Grande Valley. Sometimes we watched dust devils swirl soil around and around for miles until they disappeared. Wild rabbits, turkeys and snakes lived up there. Sometimes the men and boys would organize a rabbit hunt. Afterward every family cooked a delicious rabbit stew.

While I was riding Teddy, sometimes he would stop and give a snake time to slither away. Wildflowers grew so beautifully up there that it was like having our own flower gardens. While we raised food on the mesa in the summer, I rode the horse to the Santa Clara Creek every day for drinking and cooking water. My greatest delight was to ride ol' Teddy. I was glad the Spanish had brought horses to our land of the Pueblos.

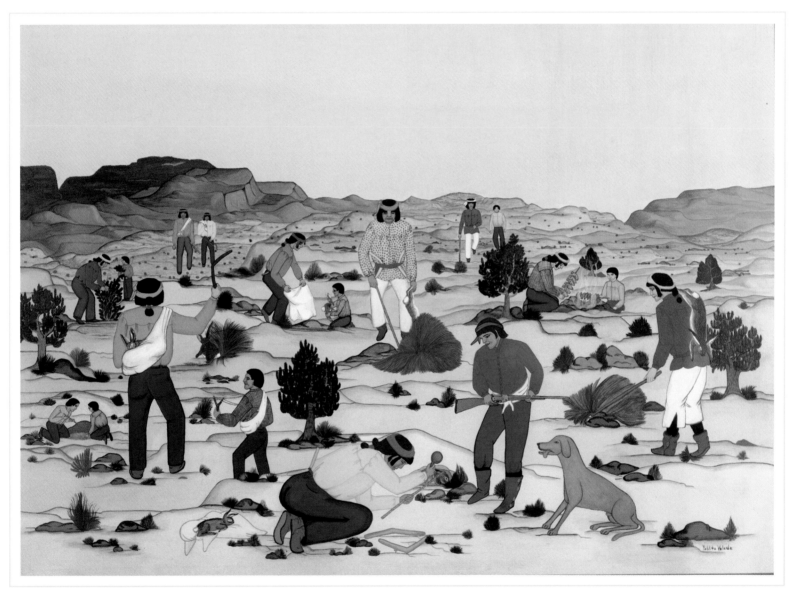

*The Rabbit Hunt at Santa Clara*

1957

Casein

Courtesy of Mr. and Mrs. B.W. Miller

P ueblos and persons both had naming days. My naming day was September 22, 1915, when I was 3 days old. My grandmother, Qualupita, offered me to the four directions, lifting me high in the air and back to the Earth from north, south, east and west. Then she offered me to the sky, held me high and, at last, lowered me to the Earth. She sprinkled corn meal, a traditional Indian symbol during a naming ceremony. She thanked the Great Spirit for my birth and asked blessing on my life. All of her prayers for me have come true.

Opposite: *Naming Of the Baby* (#51456/13

195

Museum of Indian Arts and Culture/Laboratory of Anthropology

Museum of New Mexic

Photograph by Blair Clar

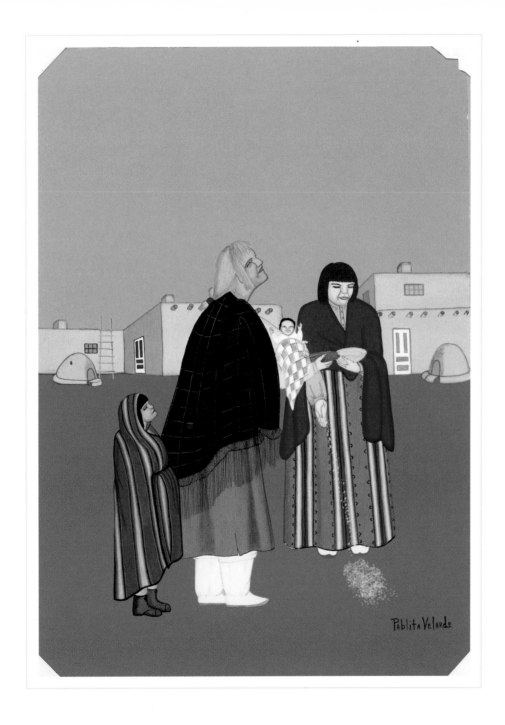

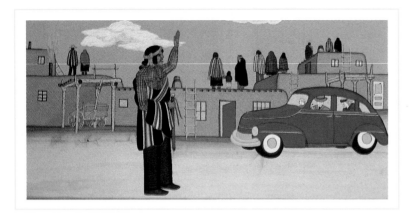

*Santa Clara Pueblo*

Ca. 1939-1946

Permanent collection of Bandelier National Monument,

National Park Service

The missionaries named our village the Santa Clara Pueblo on August 12, 1622.* This is our naming day and we have a feast day every year on the 12th of August called Santa Clara Feast Day. We have tribal dances and several kinds of food in each home. Every door is open to feed whoever visits. Guests are welcomed, honored and fed. Now that I am older, I eat with my sister Jane on feast days. We eat three kinds of chile, ham, venison or beef, corn, potatoes, salad, jello, bread pudding, cake and pie. I always liked it that my parents were married on Santa Clara Day.

*Historical records in Spain refer to building the church at Santa Clara from 1621 to 1623.

Opposite: *Santa Clara Harvest Dance*

1940

Casein

Permanent collection of Bandelier National Monument,

National Park Service

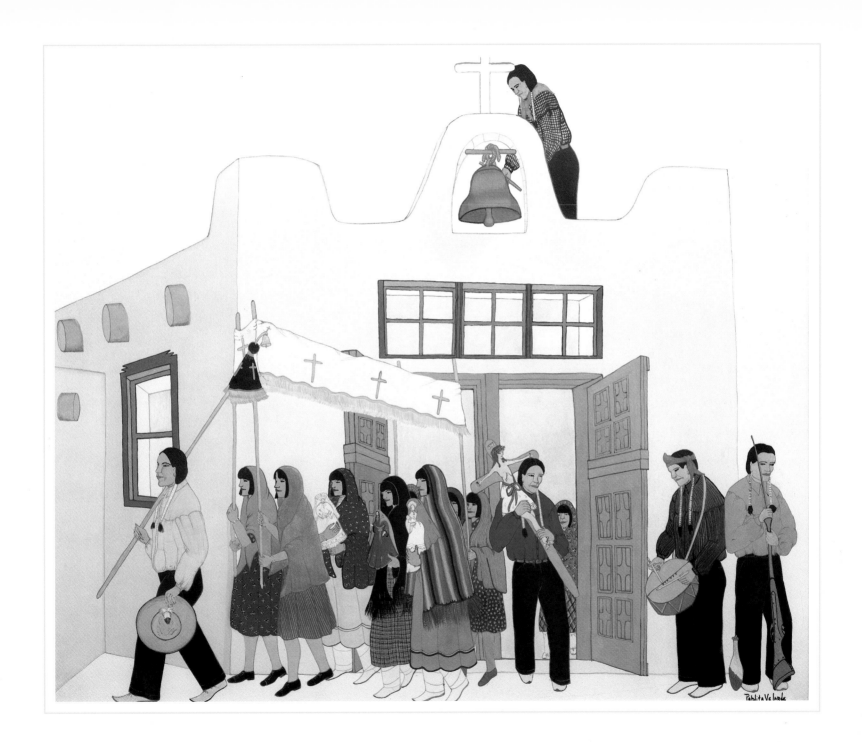

My father was proud of his girls at the dances. I could always dance for hours and hours. Once he let my sister and me dance a new dance, the Green Corn Dance, brought to our pueblo one Christmas Eve by some boys visiting from Hopi country. We knew the boys from school. First they taught us the Green Corn Dance. Then we went around the Plaza and danced for all of the families.

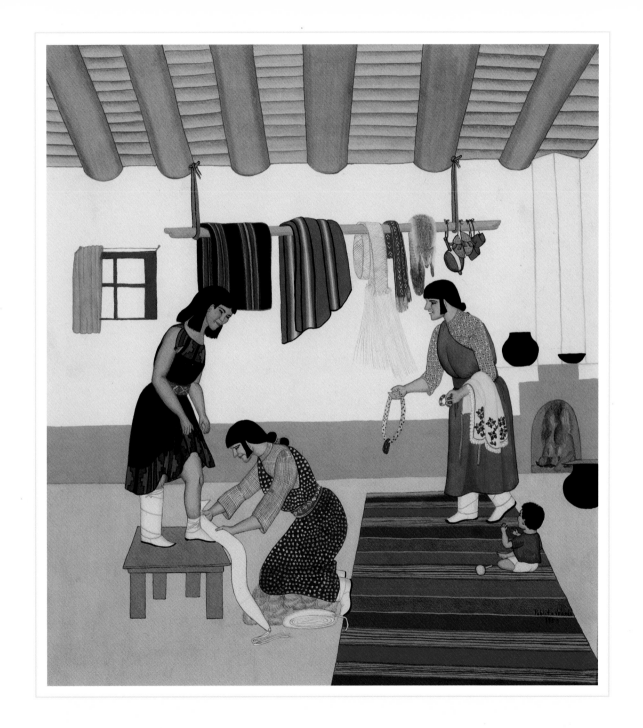

The next day, Christmas Day, we were invited to do this dance for the Christmas Celebration. Every year since then for the last 70 years the Green Corn Dance has been a part of celebrations at Santa Clara. My sister Jane and I were the first Santa Clara Indians to dance the Green Corn Dance. Now on feast day, August 12, I sit in a folding chair and watch hundreds of people dance. Often I hum the songs, as I remember every word and melody. Sometimes someone gives me an ear of green corn that has been blessed in the holy dance, and I feel honored as I remember that first dance when Jane and I were girls.

Opposite: *The Taos Horse Tail Dance*

1960

Casein

Courtesy of Mr. and Mrs. B.W. Miller

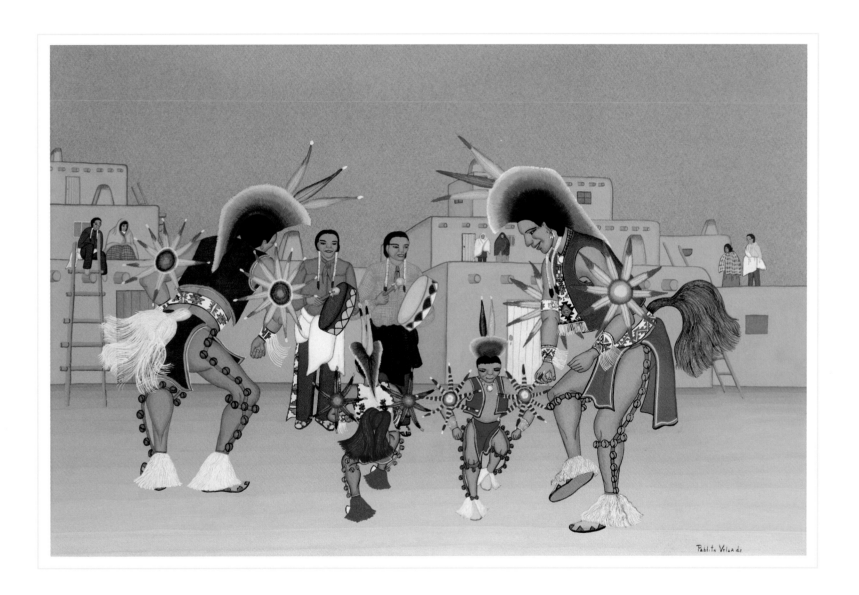

Pablita Velarde

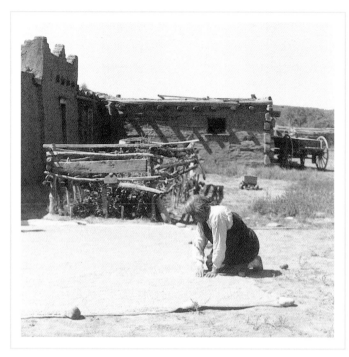

Drying Grain, Santa Clara Pueblo
Ca. 1935

Photo by T. Harmon Parkhurst
Courtesy Museum of New Mexico,
Neg. No. 46088

Opposite: *Drying the Wheat*
1942
Casein
Permanent collection of Bandelier National Monument,
National Park Service

I n late summer after my father harvested the wheat, it was my grandmother, Qualupita, who took charge of washing it. She carried a large basket to the Santa Clara Creek and she had each of her grandchildren bring a pail. Then she poured some wheat into this large basket. We grandchildren poured water from the creek into the basket. Grandmother stirred the wheat with the water running over it until all the dirt had washed through the bottom of the basket. We were kept carrying pails of water all day. She could keep 25 children busy pouring water to clean the wheat. After my grandmother cleaned a sack of wheat, she spread it out to dry on large sheets of *Tah-ah*, white canvas, like covered wagon canvas. Then when it was dry, she and my father put in back in the sacks. My grandmother and my father were both tired every evening.

After the wheat was all clean, dry and re-sacked, my father took it to Española to the mill to be ground into flour. When he brought the flour back home, he shared flour with everyone who helped grow, clean or harvest the wheat. Everyone always wanted to help my father because they knew he would share. I wish people were still like that.

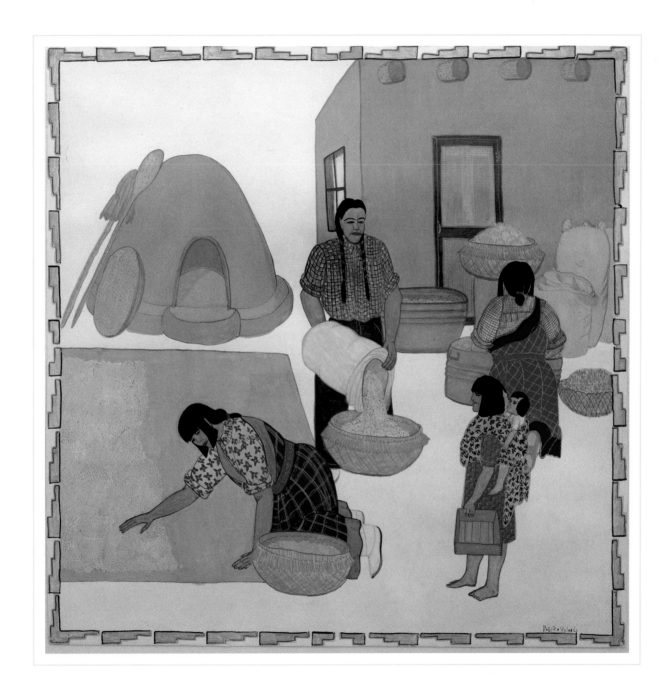

Dorothy Dunn

1964

Photographer unknown

Courtesy of Pablita Velarde

When I finished sixth grade at St. Catherine's, I was allowed to skip seventh grade. I started eigth grade at the Santa Fe Indian School. Part of my education at the Indian School was an art class taught by Miss Dorothy Dunn. My sister took art with me for a while, but when she quit, I was the only girl in the class. Miss Dunn had to keep me beside her desk for protection. The boys were always teasing me and sometimes they were mean. They didn't want me in the class anyway because they didn't believe women should be artists.

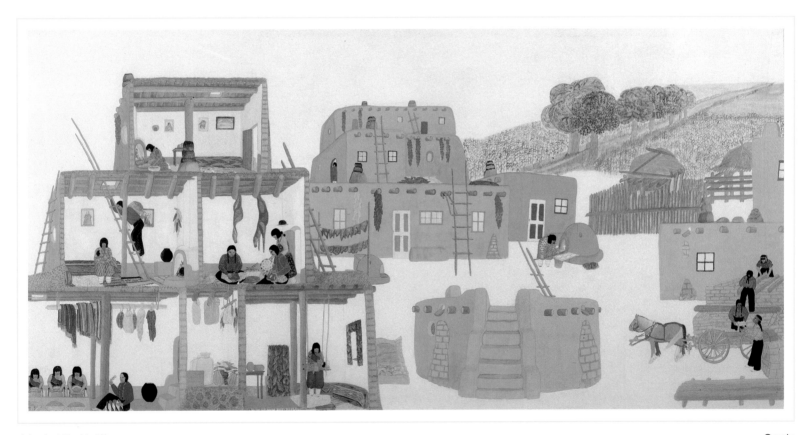

*A Look at Pueblo Life*

1941

Casein

Permanent collection of Bandelier National Monument,

National Park Service

Miss Dunn was always wonderful to me. She quickly recognized my special talent for art. She encouraged me to make pictures of my life at home that told about the pueblo and the traditional Indian ceremonies. Art became my favorite subject. Miss Dunn taught me to grind rocks and raw clay to make beautiful earth colors for my paintings. I ground the different earth colors with the *mano* and *metate* like the ancient Indians had once ground corn for tortillas. After I left school, I continued to develop my unique earth-painting technique. It helped me find recognition in the world of art. I still paint with several mediums, including earth pigments. I dig the dirt in secret places. I strain it and keep it in jars in my studio. When I am ready to paint with the earth colors, I mix it with glue and water, a little bit at a time. I have to use it all up that day. The earth colors are my favorite medium. I feel at peace with my soul when I am working with the Earth.

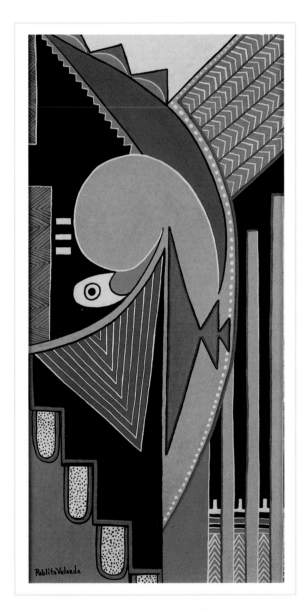

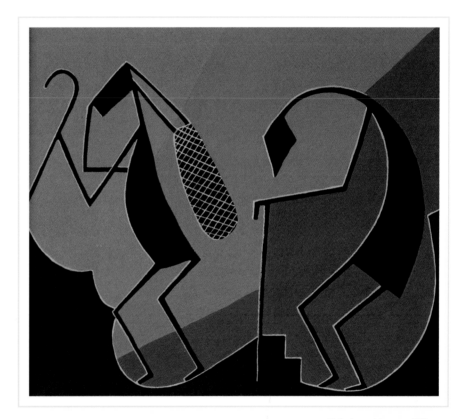

*Hohokam Man and Woman*

1968

Earth pigment

Courtesy of Mr. and Mrs. B.W. Miller

*Hope Eagle Motif*

1957

Earth pigment

Courtesy of Mr. and Mrs. B.W. Miller

I was always grateful that Miss Dunn helped me enter art contests. While I was still in school, I received many prizes and honors for my art work. I still have my first prize, a blue ribbon, now faded.

After I graduated from the Indian School, the National Park Service hired me to paint scenes of the daily life of Pueblo Indians. I worked at Bandelier National Monument from 1939-1946 under the WPA program. I stayed at Bandelier with kind people while I worked. Between projects I went home to Santa Clara. My father had remarried and his small house at Santa Clara had three small children. I wanted my own peaceful home where I could create a studio. I talked my father into giving me his chile patch next to his house. There I built myself a small adobe home with my earnings from the National Park Service. I was the first woman to build and own her own home at the Santa Clara Pueblo. Many people said I was crazy.

Opposite: *Santa Clara Rain Dance*
1989
Casein
Courtesy of Mr. and Mrs. B.W. Miller

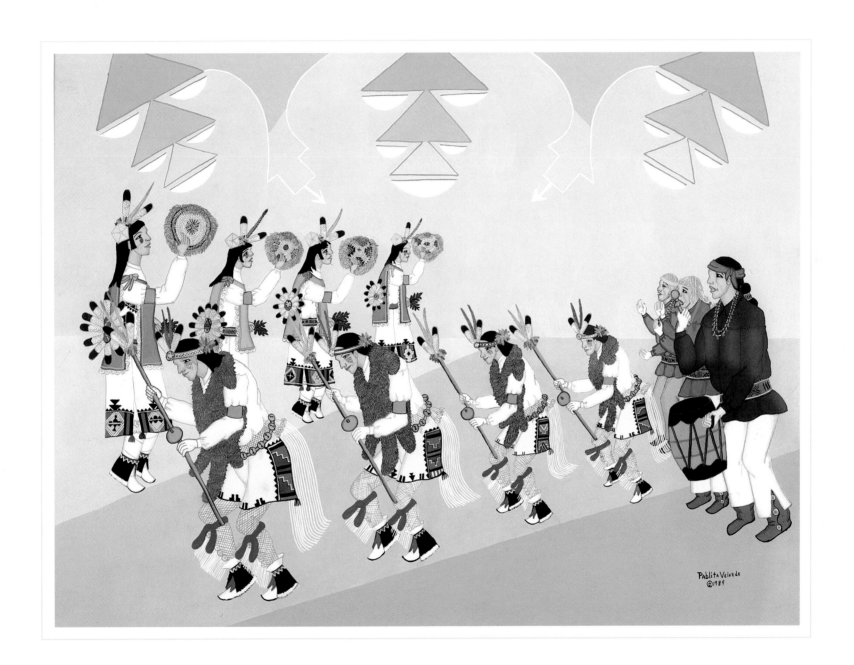

M iss Dunn had taught me to enter my art in competitions. Over the years I won first prize dozens of times. Two awards that I treasure are the 1968 Wade-Phillips Trophy from the Gilcrease Museum in Tulsa, OK, and the 1955 Palmes Academique award from the French Government. One of my fantasy trips is to go to the Louvre in Paris and see my art hanging there with the old Masters from all over the world.

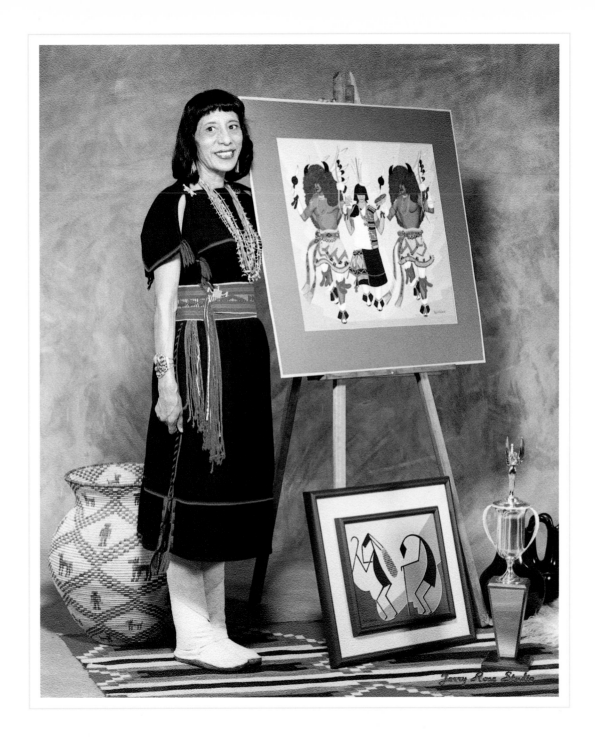

49

One summer I traveled while working as a nanny for Ernest Thompson Seton, the famous naturalist who founded the Boy Scouts of America. The waiter in a hotel in Ohio thought I was black and refused to feed me.

Mr. Thompson raised plenty of ruckus with the hotel manager; after that I was well-treated. I decided never to judge a person by the color of their skin. I have known prejudice from tribal custom, from neighbors, from Indians against my children who are of two races, and as a divorced woman. Yet, I have spent my life fighting prejudice in my own way. Now that I am famous, I usually find acceptance. But I still believe that prejudice is hurtful and evil.

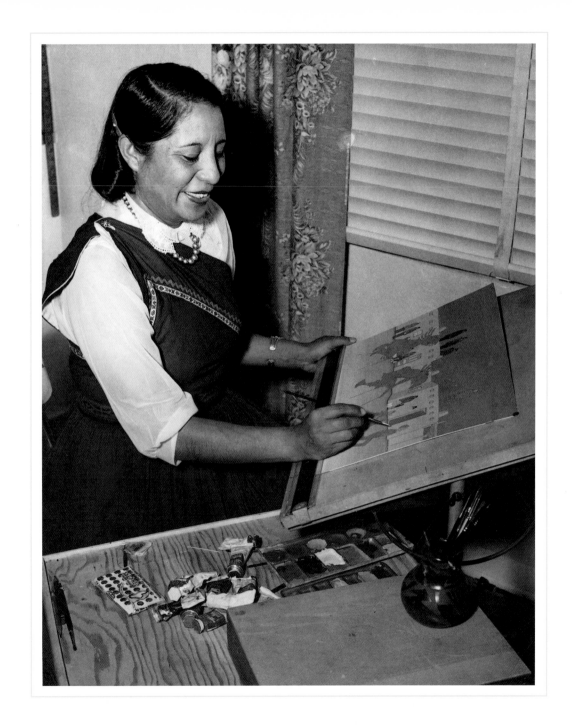

After painting at Bandelier for many years, I went to work in Albuquerque at the Bureau of Indian Affairs as a switchboard operator. There I met Herbert Hardin. When I was at the Indian School, the boys had all seemed like brothers to me. I was in my 20s when I met Herbert. He was a police officer for the Bureau of Indian Affairs. I thought I had found love. We were married at the St. Francis Cathederal in Santa Fe on Valentine's Day, 1941. My family had already come to think of me as an old maid. However, they were unhappy that I had married a non-Indian. They knew that our children would not be able to vote or own land at the Santa Clara Pueblo. That is still true.

A few months after our marriage the U.S. Army drafted Herbert to serve his country and fight in World War II. He was gone seven years. I moved back to my home at Santa Clara and began to paint again. He came home now and then, and from those seven years we had a little girl named Helen and our son, Herbert. After the war when he came home, we moved back to Albuquerque and tried to resume our marriage, but we discovered we were strangers.

Opposite: *Indian Madonna Kneeling at Shrine*

1962

Casein

Courtesy of Mr. and Mrs. B.W. Miller

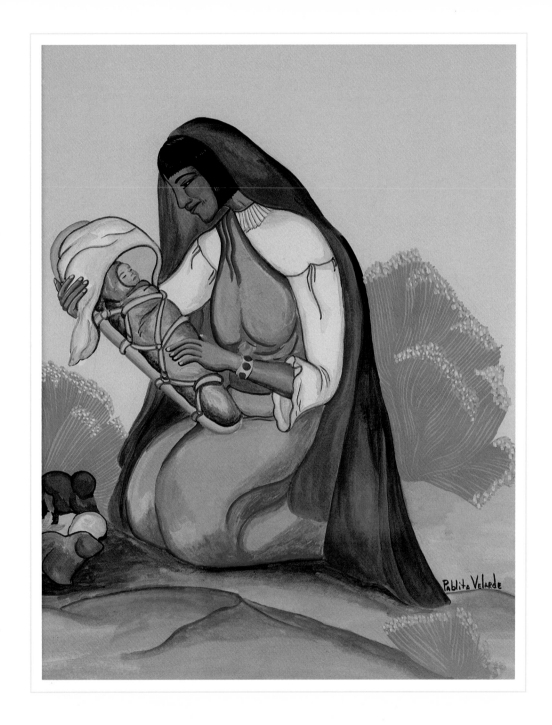

I learned to be independent while Herbert was gone and continued to develop my artistic talent. I even started selling pictures. I used to put my pictures up with thumbtacks on lean-to boards under the portico of the Palace of the Governors in Santa Fe. All my paintings sold, but for quarters or a few dollars, not for thousands of dollars, as they do now. Painting became my life. I ate, breathed and dreamed painting.

Finally, Herbert went to Washington, D.C., to work for the CIA. He sent me a little money each month while the children were small, but it was selling my pictures that really paid to raise the two children. When times were difficult I remembered my hard-working father who raised four little girls without their mother. He inspired me.

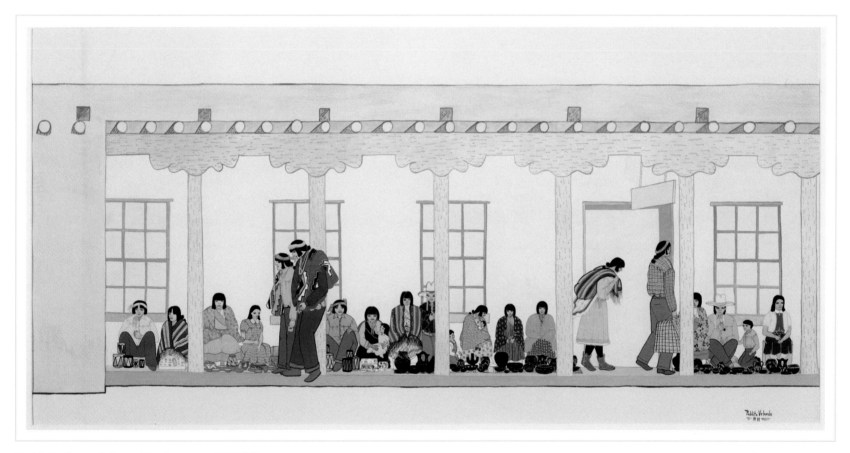

*Pueblo Craftsmen, Palace of the Governors*  (#0237.565)

Tempera on paper

1941

From the Collection of Gilcrease Museum, Tulsa, OK

When I really needed money, I used to call Fred and Margaret Chase who owned a gallery on Central Avenue in Albuquerque called Enchanted Mesa. They always bought my art. They were the first patrons to believe in me as an artist and support my developing talent. Margaret and I became best friends, and we even pricked our fingers to become blood sisters.

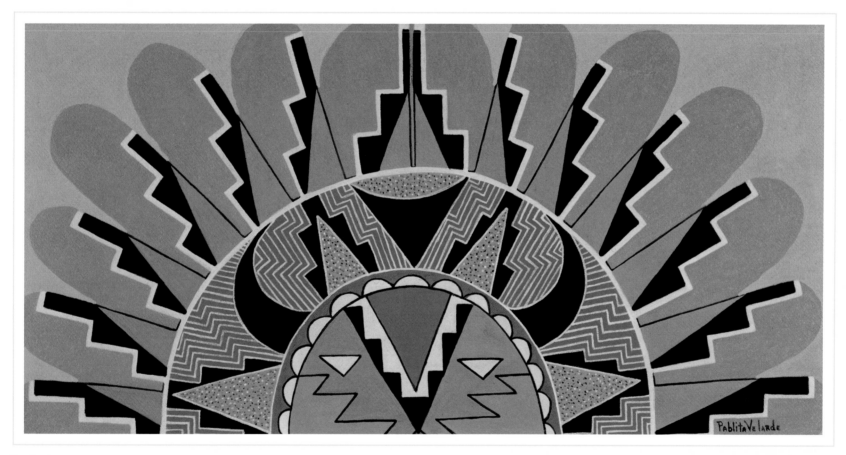

*The Sunrise*

1970

Earth pigment  12" x 23 1/2"

Courtesy of Mr. and Mrs. B.W. Miller

As my children grew, I told them the stories my father told me around the fireside at night. My children had trouble picturing those stories in their minds. So I drew a picture and wrote the story down. Then when I read them the story with the picture, they understood it. Gradually, I wrote several stories and I made pictures to go with each story. My children loved them. I figured that if this helped my children it would help others. I had trouble remembering them, so I asked my father to help me write them down. My father helped me reluctantly because he believed that telling a story was better than writing it. I decided to write all those old stories into a book so that every Indian child and children of every race could forever have these Indian stories. The book is called *Old Father Storyteller* and was first published in 1962. It is still in print.

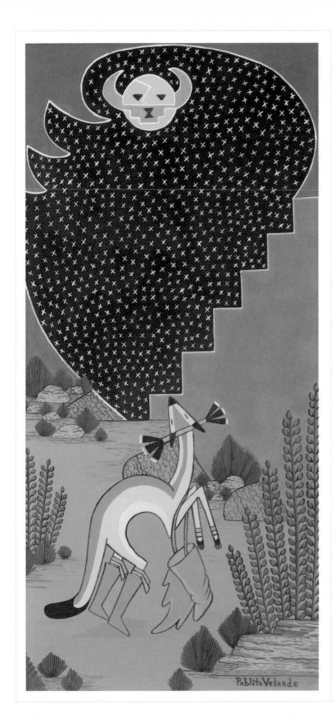

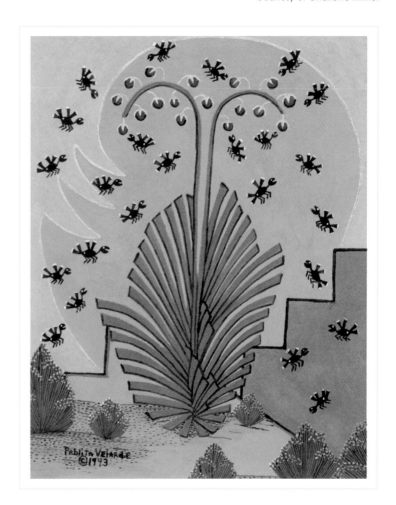

*Why the Coyote Bays at the Moon*

1965

Earth pigment

Courtesy of Mr. and Mrs. B.W. Miller

I found out that the reason my father was reluctant to help me write the book was a cultural belief that bad things could happen to the Santa Clara people if these stories were written. The tribal elders began to punish and chastise me for my actions. I felt it was important to write this book, but I feared retribution from the tribal elders. They believed they were right and I believed I was right. It was one of the two worst times in my entire life. I lost weight and couldn't sleep and finally had to leave the pueblo. My friends talked me into going back to live in Albuquerque for my own sanity and health. Later in my life when I was stronger, I bought another home at Santa Clara. I like having two homes. I work at my home in Albuquerque and enjoy my family and friends when I stay at Santa Clara.

Opposite: *Communicating with the Full Moon* (self-portrait)

1962

Casein  23 1/2" x 10"

Courtesy of Mr. and Mrs. B.W. Miller

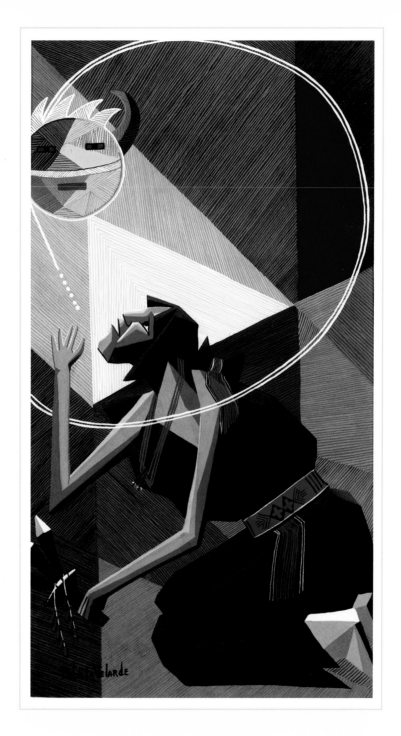

When I was a child, I always wanted to have my own doll. None of us, my sisters nor I, ever had a doll. However, as an adult I learned to sew dolls and to make them Indian clothes. I carefully braided their hair, which was made from strands of thread. I painted their faces and made Indian jewelry for them. I sewed little leather dancing boots for them. People asked to buy them and at first I hesitated to sell them. Then I found I could make money sewing dolls, so I started making some to sell every year. Over the years I have made and sold hundreds of Indian dolls. I always sign my name on one leg of each doll. I have never forgotten my childhood yearning for my own doll. I think that is the reason I feel sad for a little while when I part with each one.

Opposite: Pablita's Dolls

2000

Courtesy of Pablita Velarde

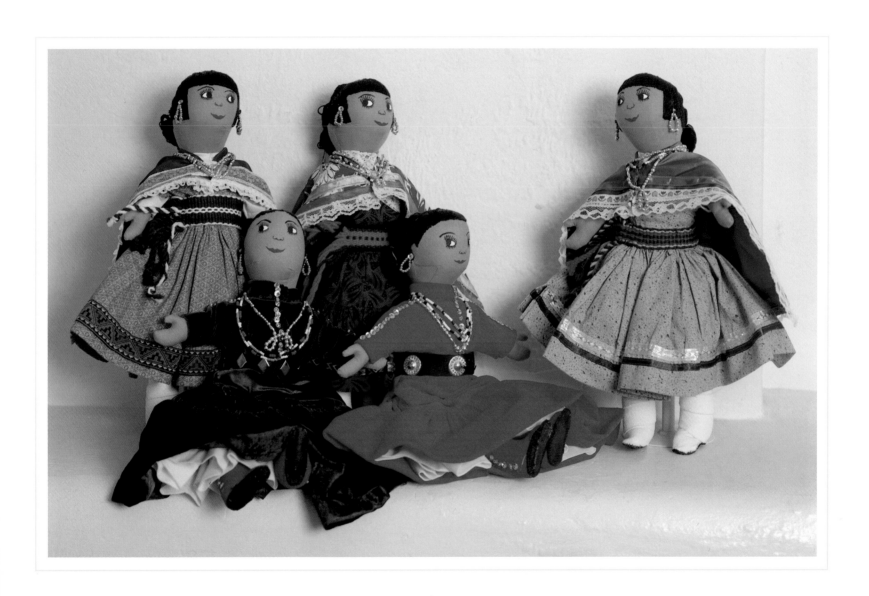

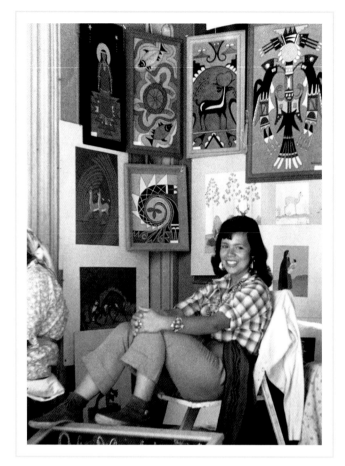

Helen Hardin

Ca. 1968

Photographer unknown

Courtesy of Pablita Velarde

My little Helen grew up to be a wonderful artist. It was amazing to watch her develop her talent. I encouraged her and told her she could do anything she wanted to do. She had a real talent and I could tell that soon she would be better at art than me. We both made giant murals at the Indian Pueblo Cultural Center in Albuquerque. Then she came down with terrible cancer and died shortly after that at the age of 41. The saddest day of my life was when I lost Helen. It was hard to bury her ashes in the graveyard at Santa Clara. The world lost a great artist the day I lost my precious Helen.

After her death, I was slow to resume painting. When I was finally able to paint again I painted the picture of life: *High Country*. Then I knew I would heal from her death.

Opposite: *High Country*

1984

Casein 24 1/2" x 19 1/2"

Courtesy of Richard M. Howard

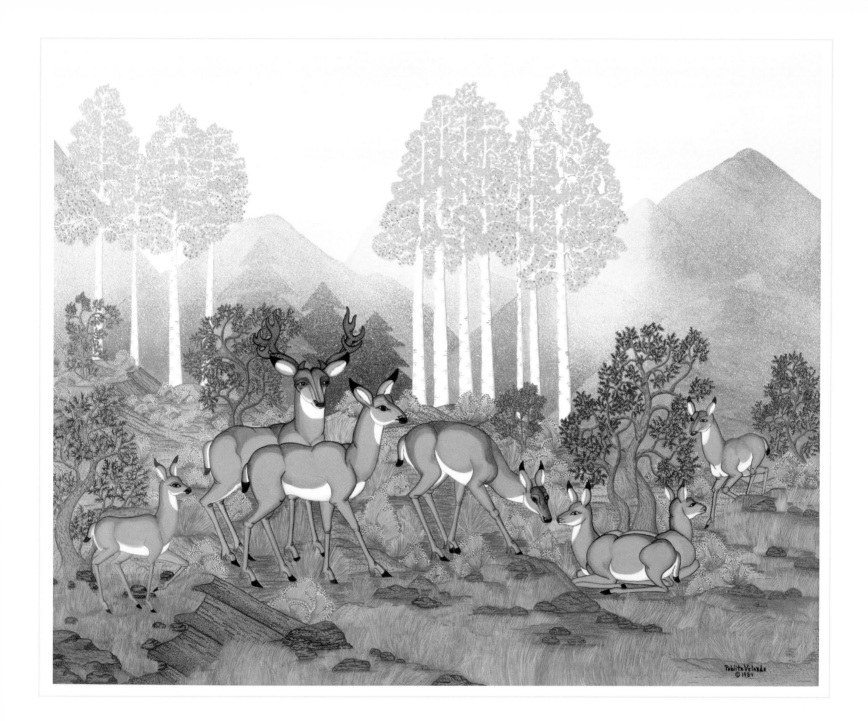

Helen left a daughter, Margarete, who is now grown and has two sweet children: Forest John and Little Helen. I like being a great-grandmother. I still have my son, Herb Jr. He is a rock for an old woman and is always there when need him.

I am more than 85 years old now, but I still paint and I still make pictures of life at the pueblo. I have received over 50 awards for my art. I have an honorary doctorate from the University of New Mexico, the Award of Excellence from the Louvre in Paris, the Lifetime Achievement Award as a Living Treasure from the governor of New Mexico and many others, more than I can name. I have spent my life painting. My dream came true.

Opposite: L-R, Herbert Hardin, Margarete Bagshaw-Tindel, Pablita Velarde
1992
Photograph by Herb Lotz
Courtesy of Pablita Velarde

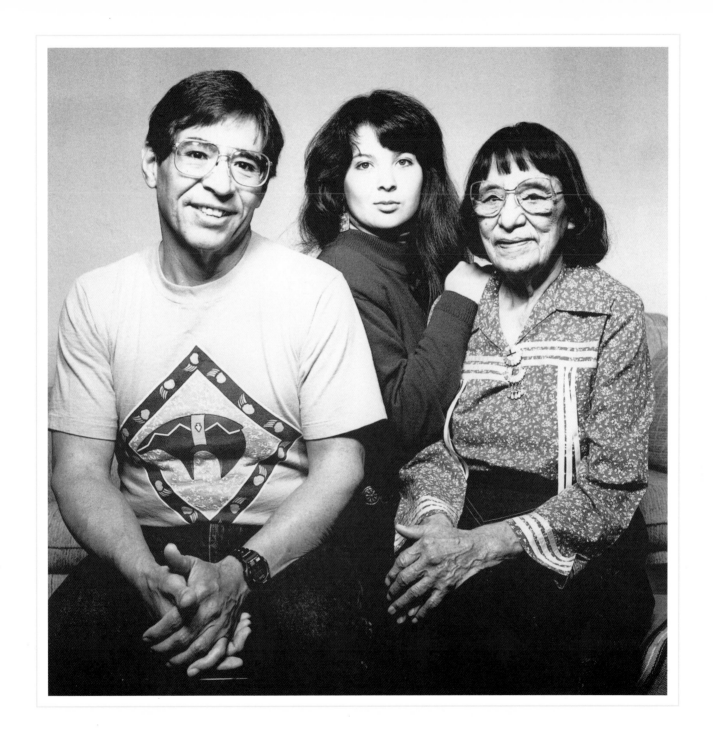

*E*very year I take three bouquets of flowers on Memorial Day to the graveyard at Santa Clara. I plant one bouquet on my daughter Helen's grave. But there is no grave marker for my mother. No one remembers where she was buried. I don't even remember her funeral. I was 2 1/2-years-old when she died of TB. By looking at her picture, I can almost remember her. So as I plant two bouquets of flowers on my father's grave, I whisper, "Dad, please give one to Mom from me."

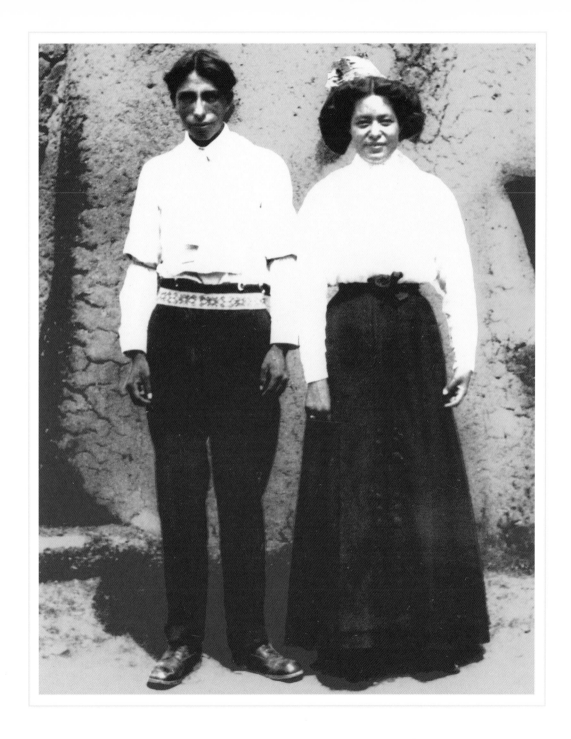

I spent years speaking about the Indian ways to non-Indian people. I volunteered in the Albuquerque Public Schools to share the ways of the Pueblo people with children. I always encouraged each child to find a dream and then to follow it. Happiness comes from discovering and developing one's own talents.

My time is coming to go live with the cloud people, when my body will be put in the graveyard at Santa Clara. I hope that my art has made a difference. I hope it will help people remember the traditions and ceremonies of the Santa Clara Pueblo. I hope the stories I have written and the pictures I have painted will teach children and adults everywhere that the Santa Clara are a truely remarkable Indian people.

Opposite: *Santa Clara Feast Day*

1939

Casein

Permanent collection of Bandelier National Monument,

National Park Service

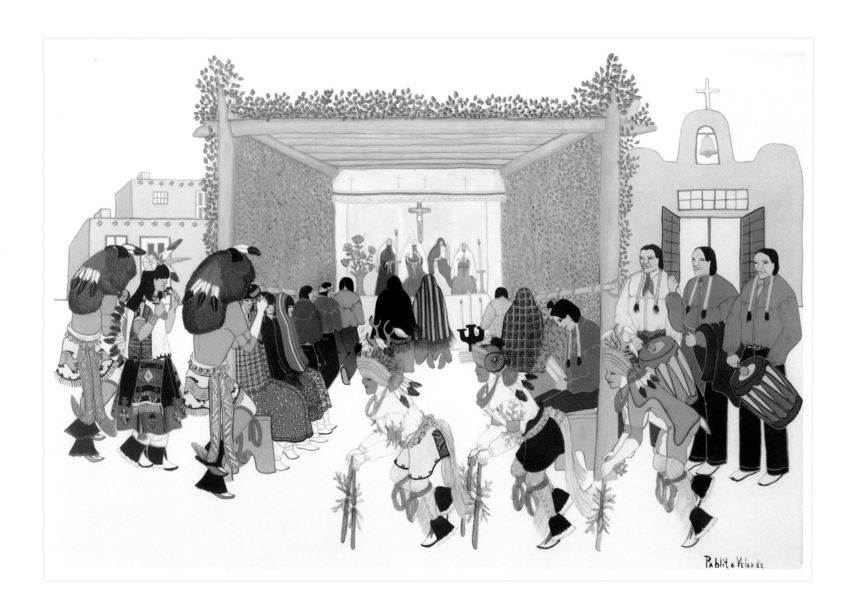

# PABLITA VELARDE
**painter, illustrator, lecturer, writer**

Born: Santa Clara Pueblo, NM
September 19, 1915
Studied: Dorothy Dunn, Santa Fe Indian
School, Santa Fe, NM

MEMBERSHIPS:
Art League of NM, The National League of
American Pen Women, Internationale
Toastmistress Clubs Inc. (Kachina Branch),
Inter-Tribal Indian Ceremonial Assn., Louvre
of Paris (lifetime)

AWARDS:
1949    Second Purchase Award,
        Philbrook Art Center, Tulsa, OK
1953    Grand Prize, Philbrook Art Center,
        Tulsa, OK
1954    Purchase Award, Denver Art
        Museum, Denver, CO
1955    1st Grand Prize, 1st Special Award,
        1st Poster Award, 3rd Grand
        Award, Gallup Ceremonial,
        Gallup, NM; Purchase Award,
        DeYoung Museum, San Francisco,
        CA; 2nd Award, Philbrook Art
        Center, Tulsa, OK; 2nd Prize,
        Penwomen's Biennial,
        Albuquerque, NM
1955    Palmes Academique award from
        the French Government, Gallup
        Ceremonial, Gallup, NM
1956    1st Award, Philbrook Art Center,
        Tulsa, OK

## Vita

1957    1st Award, Philbrook Art Center, Tulsa, OK
1958    Purchase Award, Museum of New Mexico Art Gallery,
        Santa Fe, NM
1959    Twentieth Century Art Club of St. Louise Award, Museum
        of New Mexico Gallery, Santa Fe, NM; 1st Award,
        Philbrook Art Center, Tulsa, OK; 1st Award, Gallup
        Ceremonial, Gallup, NM; two 2nd Awards and 3rd
        Award, New Mexico State Fair, Albuquerque, NM
1960 -1970  Information Not Available
1977    Governor of New Mexico Award for Achievement in the
        Arts, Santa Fe, NM
1978    Honorary Degree, Doctor of Letters, University of New
        Mexico, Albuquerque, NM
1984    SWAIA, 63rd Indian Market, 1st Prize, Santa Fe, NM;
        SWAIA, 63rd Indian Market, 3rd Prize for Pueblo dolls,
        Santa Fe, NM
1985    SWAIA, 64th Indian Market, 1st Prize, Santa Fe, NM
1986    Inter-Tribal Indian Ceremonial, Best in Category, Gallup
        NM
1987    Native American Indian Culture, Woodard's Award,
        Scottsdale, AZ; Cherokee National, Trail of Tears, Best in
        Class, OK
1988    Living Treasures, Santa Fe, NM; SWAIA, 67th Indian
        Market, 1st Prize, Santa Fe, NM; Eight Northern Indian
        Pueblos Arts & Crafts, 1st Prize, San Ildefonso, NM
1989    SWAIA, 68th Indian Market, 1st Prize, Santa Fe, NM;
        SWAIA, 68th Indian Market, Best in Category, Helen
        Hardin Memorial Award, Santa Fe, NM; Eight Northern
        Indian Pueblos Arts & Crafts, 1st Prize, San Ildefonso, NM
1990    SWAIA, 69th Indian Market, Helen Hardin Memorial
        Award, Santa Fe, NM; Women's Caucus for the Arts,
        New York City, NY; The Erna S. Fergusan Award, UNM
        Alumni Association, Albuquerque, NM
1991    Eight Northern Indian Pueblos Arts & Crafts, Best in
        Tradition, Special Award, San Ildefonso, NM.
1994    Lifetime Award, Heard Museum, Phoenix, AZ; Magnifical
        Award, Albuquerque, NM

1996    Rounder's Award, College of Las Cruces – presented by
        Governor Gary Johnson and the Director and
        Secretary Frank A. Dubois
1997    SWAIA Lifetime Achievemnet Award, Santa Fe, NM;
        N.A.A.S.A. Lifetime Contribution, North American Artist,
        Berkeley, CA
1999    New Mexico Governor's Award for Achievement in the
        Arts, Museum of Indian Arts and Culture, Santa Fe, NM
2000    March 25, National Women's History Month, 1st Annual
        Indian Pueblo Cultural Center National Women's History
        Awards, Albuquerque, NM; Award from Heather Wilson,
        Member of Congress, Albuquerque, NM; New Mexico
        Committee of the National Museum of Women in Arts,
        Santa Fe, NM

PUBLIC MURALS:
1939-46  Bandelier National Monument, NM
1940    Maisel Building, Albuquerque, NM (casein on wet plaster)
1957    Foote Cafeteria, Houston, TX (oil)
1958    Western Skies Hotel, Albuquerque, NM (earth pigments)
1960    Santa Fe Bank, Los Alamos branch (oil)
1975    Indian Pueblo Cultural Center, Albuquerque, NM (acrylics)

EXHIBITIONS:
1955    M.H. DeYoung Memorial Museum, San Francisco, CA; New
        Mexico Annual Artists Exhibit, Santa Fe, NM; James
        Graham & Sons, New York City, NY; Rodeo de Santa Fe
        (cowboy exhibit), Santa Fe, NM; Chapell House (Denver
        Art Museum) Denver, CO; Fez Club, Albuquerque, NM
1955-1959  Gallup Ceremonial, Gallup NM
1956    James Graham & Sons, New York City, NY
1957    Indian Center, Los Angeles, CA
1958    National League of American Pen Women, State Fair
        Museum, Albuquerque, NM; California Palace of the
        Legion of Honor, San Francisco, CA
1959    New Mexico State Fair, Albuquerque, NM; Cheyenne,
        WY; Enchanted Mesa, Albuquerque, NM; Hall of

Ethnology, Santa Fe, NM; Albuquerque Public Library (Los
Griegos Branch); Anadarko Exposition, Anadarko, OK;
Desert Arts & Crafts, Tucson, AZ; Clay Locketts Gallery,
Tucson, AZ; Vaughan's Town & Country Shop, Phoenix,
AZ; SWAIA, Santa Fe, NM; Eight Northern Indian Pueblos
Arts & Crafts, San Ildefonso Pueblo and San Juan Pueblo,
NM
1996    Retrospective show at Wheelwright Museum, Santa Fe,
        NM

JURIED EXHIBITS:
1954    Philbrook Art Center, Ninth Annual Exhibition of
        Contemporary American Indian Paintings, Tulsa, OK
1989    State Fair Indian Art Exhibit, Albuquerque, NM
1990    SWAIA Indian Market, Santa Fe, NM
1991    Adults Exhibit, Indian Culture Center, Albuquerque, NM;
        Children's Exhibit, Indian Pueblo Cultural Center,
        Albuquerque, NM

AUTHOR:
1962    *Old Father Storyteller* (reprinted 1990)

ILLUSTRATIONS:
        Cover for *Indians of Arizona*, Kenneth M. Stewart (King
        Publishing Co.)
        *Old Father Storyteller*

TELEVISION:
        Painting demonstration for KOB-TV, Albuquerque, NM
        Documentary, NMSU, Las Cruces, NM
        Documentary, Bandelier National Monument,
        National Park Service
        Documentary, *Modern Maturity*, NY
        "Colores," UNM, KNME-TV, Albuquerque, NM (1996)

# Acknowledgements

Foremost, to Pablita Velarde, whose life and art inspired me. Second, to my partner always and in all ways, Peter J. Ruch, who encourages me to do and be all that I dream. Also to my son, Kirk McMain, who heartened me with food and lodging for Pablita research throughout several years and places. To Judith McKay Harbert (Judy), whose artistic sense recognized the cover when we saw it at Mr. Howard's home. Also, Judy took photos and pushed me toward Pablita's art, which is what really makes this book special. Uncountable thanks for the usage of artwork go to Gary Roybal, curator at Bandelier National Monument, and private collectors Mr. and Mrs. B.W. Miller, Mr. Richard M. Howard and Mrs. Charlotte Mittler. All of these generous people encouraged me by making art available for this publication.

T.G. Mittler of Mittler Photography has been an outstanding resource. His attitude and delight about the book was shared by his lovely wife and assistant, Sally Mittler.

My editor, Bette Brodsky, who liked my story and convinced the powers that be at *New Mexico Magazine* to take a chance on a new author.